IT'S OK
TO FEEL
THINGS
DEEPLY

Library of Congress Cataloging-in-Publication Data available.

ISBN: 978-1-4521-6351-2

Manufactured in China.

Design by Sara Schneider

10 9 8 7 6 5

Chronicle books and gifts are available at special quantity discounts to corporations, professional associations, literacy programs, and other organizations. For details and discount information, please contact our premiums department at corporatesales@chroniclebooks.com or at 1-800-759-0190.

Chronicle Books LLC
680 Second Street
San Francisco, California 94107

www.chroniclebooks.com

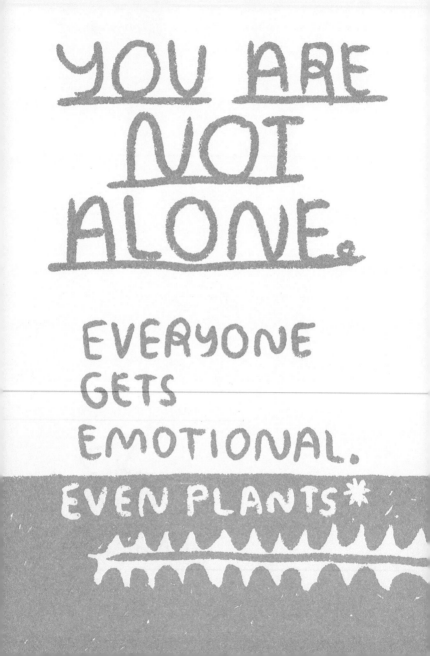

* WE ARE
ALL MADE
OF THE
SAME
STUFF

SOMETIMES ALL
EMOTIONS SEEM
TO TURN INTO
SADNESS

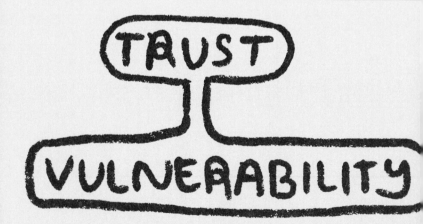

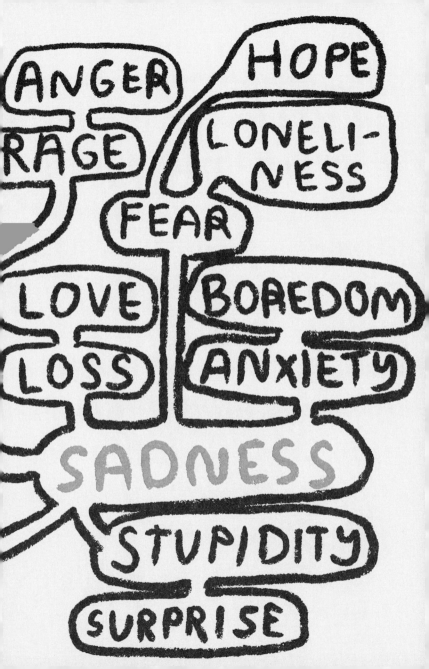

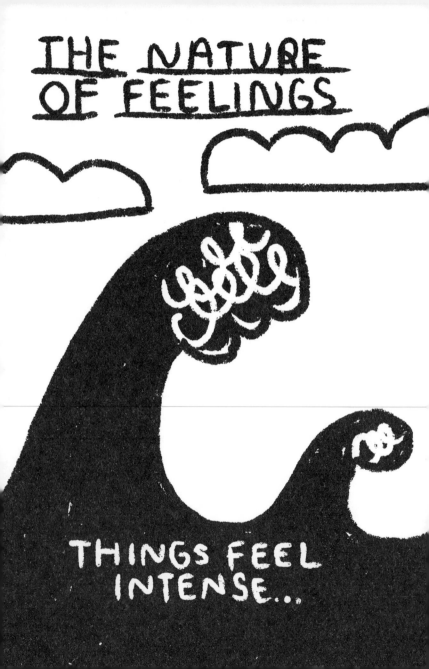

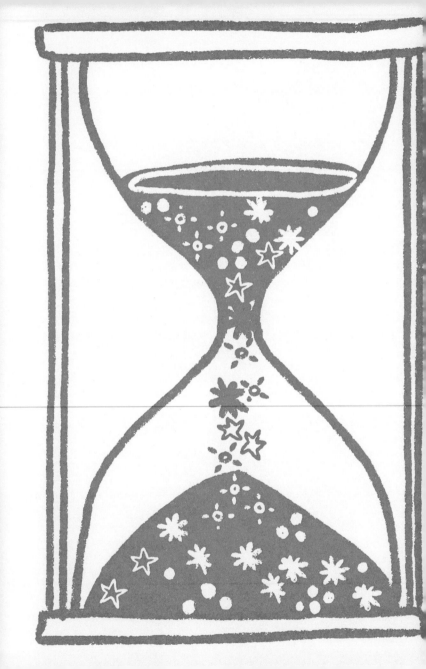

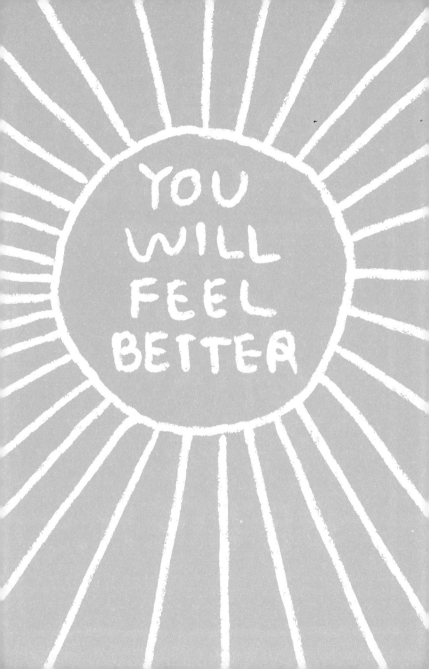

RESEARCH
SHOWS
THAT
YOU
CAN
FEEL
BETTER...

... BY BEING AWARE, TAKING SMALL STEPS FOR YOURSELF, ASKING FOR HELP & ALWAYS KNOWING THAT YOU ARE LOVED.

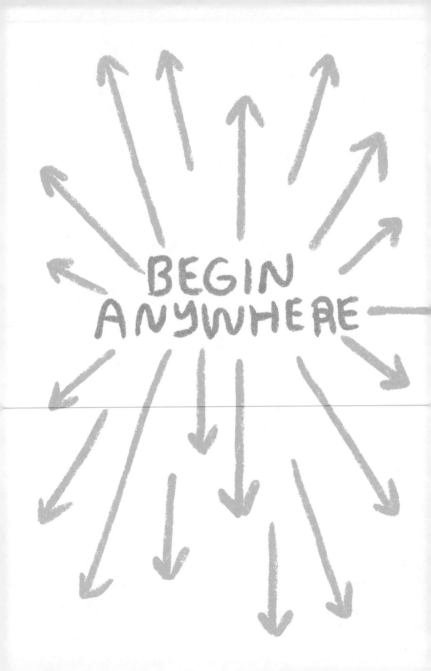

A GOOD PLACE
TO START
MIGHT BE BY
NOTING YOUR
THOUGHT
PATTERNS &
BEING AWARE
OF YOUR
FEELINGS

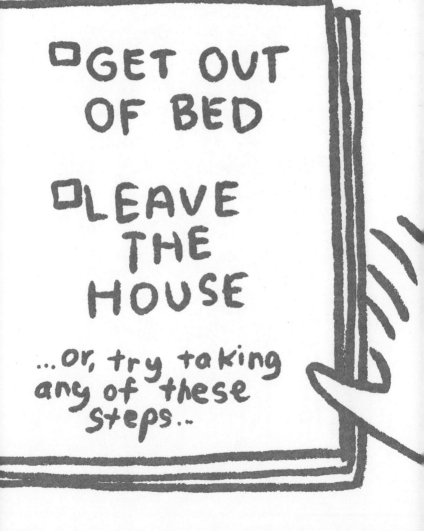

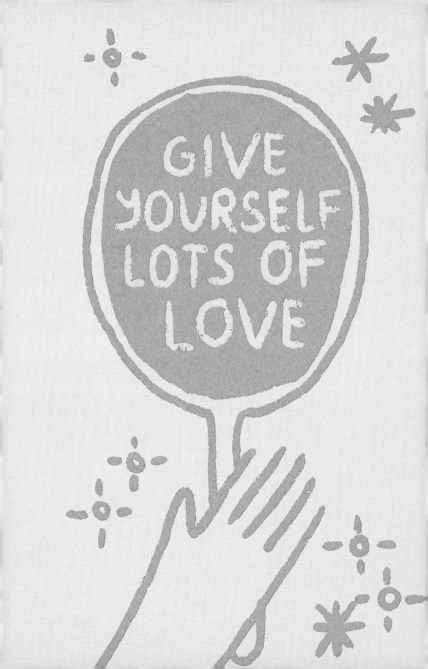

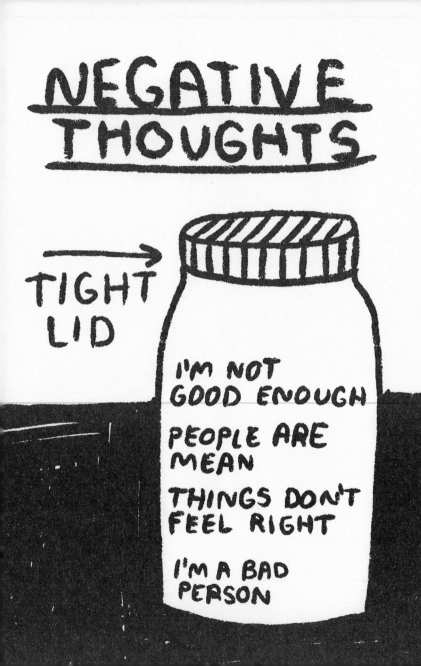

AFTER SOME TIME A FORCED SMILE MIGHT FEEL REAL.

GET COMFY
WITH UNCERTAINTY

*high dive
into the unknown*

*IT'S JUST
YOUR BRAIN
WANTING MORE
INFO

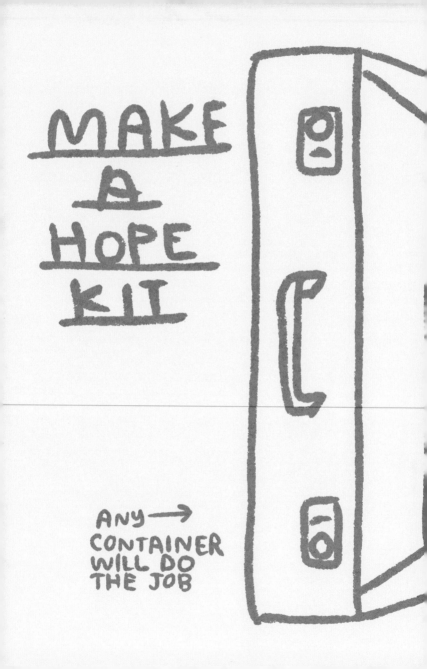

FILL WITH:

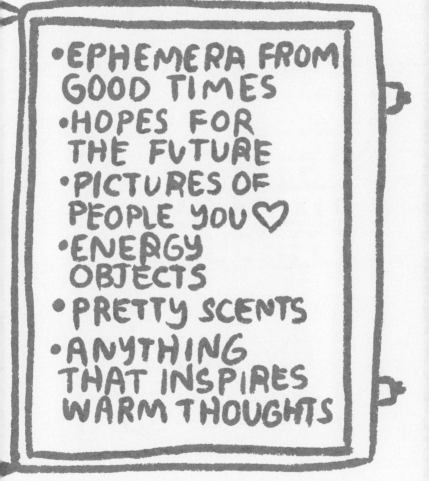

- EPHEMERA FROM GOOD TIMES
- HOPES FOR THE FUTURE
- PICTURES OF PEOPLE YOU ♡
- ENERGY OBJECTS
- PRETTY SCENTS
- ANYTHING THAT INSPIRES WARM THOUGHTS

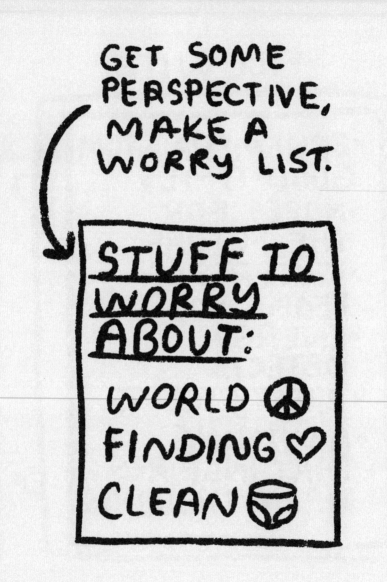

PERCEPTION
IS REALITY

FOCUS
ON THE
POSITIVE

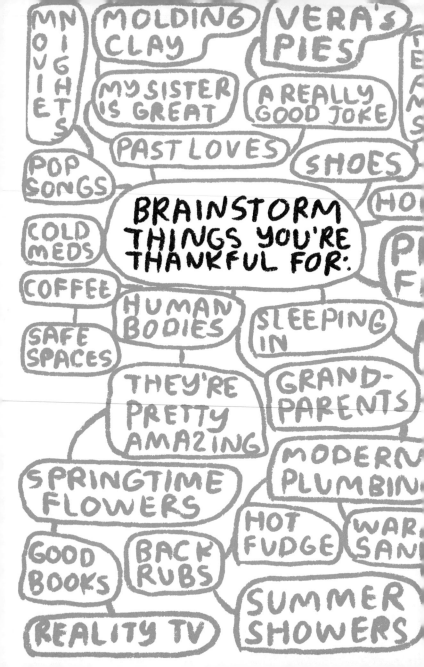

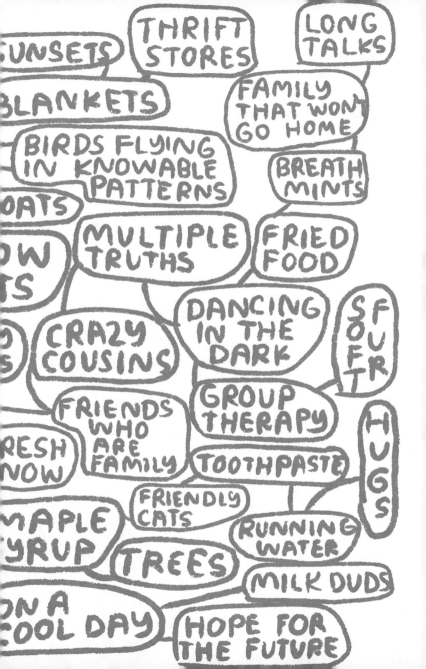

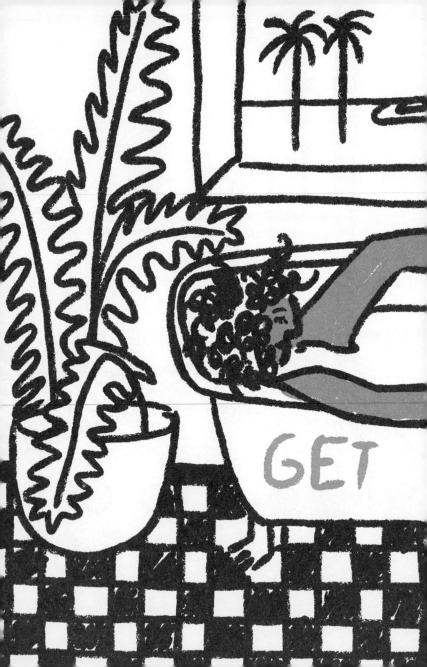

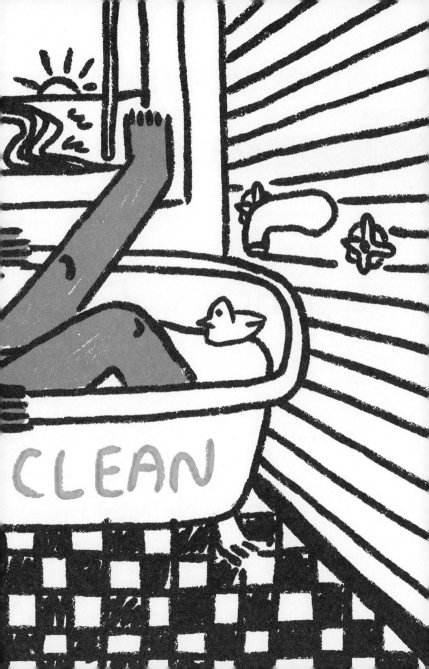

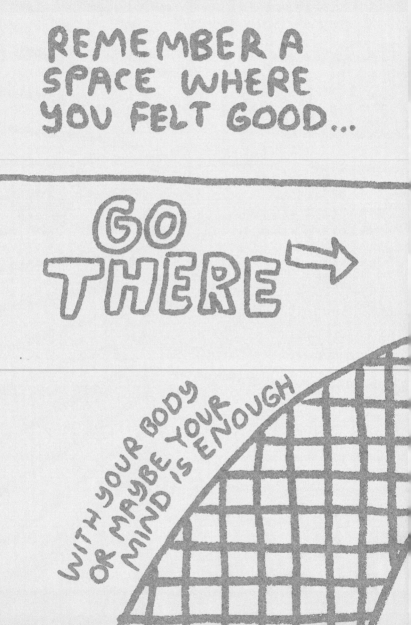

(INSERT A
PERSONAL
PLACE HERE)

PICK YOURSELF
SOME FLOWERS
(PERHAPS WHILE
NO ONE IS LOOKING)

SIT IN A
COMFORTABLE
SPOT....

FOCUS ON YOUR
BREATH & AFTER
A BIT OF TIME,

TRY RELAXING
EACH PART OF
YOUR BODY,

STARTING AT
YOUR TOES &
MOVE SLOWLY
UP...

NOTE THE
TENSE SPOTS.

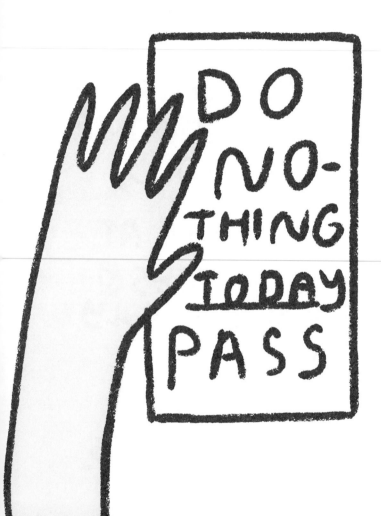

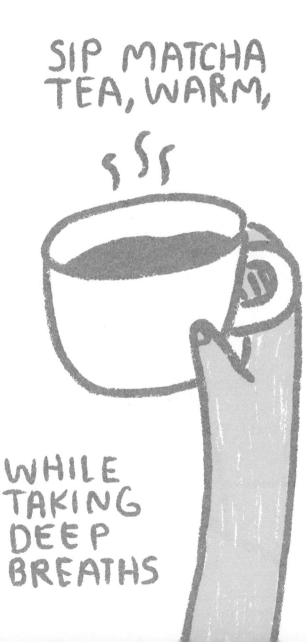

I.E.
WHEN YOUR
INNER VOICE
IS ALL LIKE
"YOU SUCK."

ASK YOURSELF
WOULD YOU
EVER SAY THAT
TO SOMEONE
ELSE?

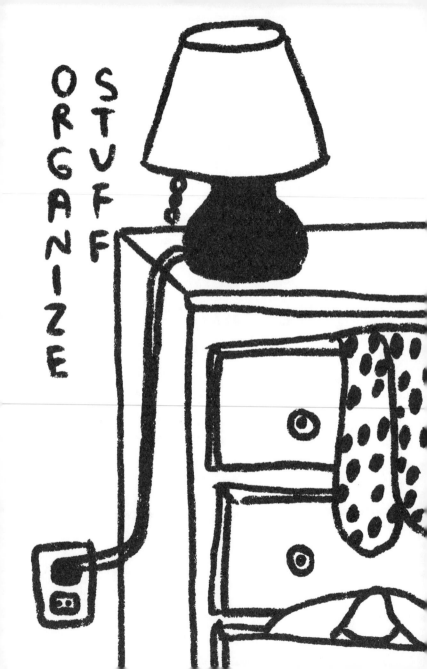

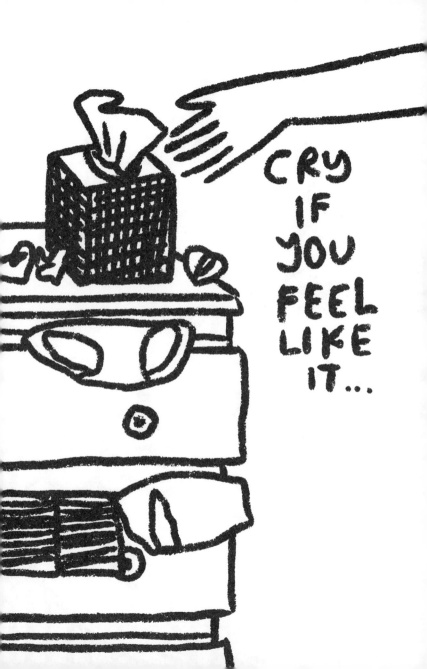

THINK ABOUT THE SUPPORT YOU GET FROM ALL LIVING BEINGS...

GET
SOME SUN.
IMAGINE THE
SUN GIVING YOU
LOTS OF ENERGY.

JUST DANCE.
IF THIS IS A
PROBLEM, TURN
OFF THE LIGHTS.

MAKE AN APPT
THAT YOU'VE
BEEN PUTTING OFF...

VISIT A THRIFT STORE & TREAT YOURSELF

GET SPIRITUAL

BURN SAGE TO
WARD OFF EVIL
& LURKING
NEGATIVE THOUGHTS.

CAST A SPELL:

- LIGHT A CANDLE
- CLOSE YOUR EYES
- IMAGINE YOURSELF IN A SAFE & COMFORTABLE SPACE

- YOU ARE
 RELAXED

- YOU ARE
 LAUGHING
 & HAPPY

- JUST BE HERE
 FOR AS LONG
 AS YOU NEED

BLAME IT
ON THE
MOON

(or stars, or mercury might be in retrograde...)

IN OTHER WORDS, CHECK IN WITH LIFE FORCES LARGER THAN YOU, LIKE THE UNIVERSE.

PRIORITIZE
AN
ADVENTURE

THEY WANT TO BE HERE 4 YOU.

THEY MIGHT JUST NOT KNOW YOU NEED THEM.

SMILE
AT
STRANGERS

GOOD PRACTICE FOR
THE REAL THING &
YOU'll BE GLAD YOU
SAW THAT DENTIST

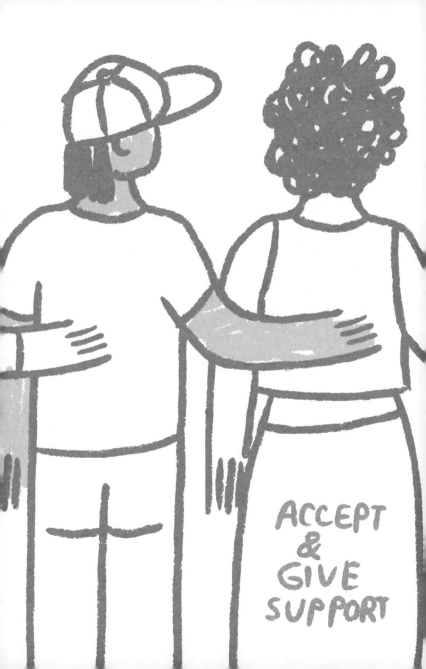

SPEND TIME
WITH SOMEONE
YOU ADMIRE &
WHO MAKES
YOU FEEL
GOOD.

TAKE COMFORT
IN KNOWING
THAT THEY FEEL
THAT WAY
ABOUT
YOU.

AND NOW
FOR
PERHAPS
THE HARD
PART:
KNOWING
DEEP DOWN
INSIDE THAT

THIS BOOK IS FOR YOU. THANKS FOR JUST BEING. TO CAITLIN KIRKPATRICK & SARA SCHNEIDER = DREAMS-COME-TRUE MAKERS. THIS IS AS MUCH YOUR BOOK AS IT IS MINE.

& FOR VERA, WHO TOLD ME IT'S OKAY TO FEEL THINGS DEEPLY. ALSO MY MOM, WHO TAUGHT ME ABOUT SWIMMING, MIE FOR SHARING HER 'CAKE FAILS' SEARCH, & JOSH. LET'S DO THIS.